Drawing MOVIE MONSTERS Step-by-Step

Drawing DRACULA

Greg Roza

WINDMILL
BOOKS ™

New York

Published in 2011 by Windmill Books, LLC
303 Park Avenue South, Suite # 1280, New York, NY 10010-3657

CREDITS:
Edited by: Jennifer Way
Book Design: Julio Gil
Art by Planman, Ltd.

Photo Credits: Cover, pp. 6, 10, 14, 20 Everett Collection; pp. 4, 5 Shutterstock.com; p. 8 © American International/courtesy Everett Collection; p. 12 Universal Pictures/ Photofest © United Pictures; p. 16 © Biosphoto/Heuclin Daniel/Peter Arnold Inc.; p. 18 © TriStar Pictures/courtesy Everett Collection.

Library of Congress Cataloging-in-Publication Data

Roza, Greg.
 Drawing Dracula / by Greg Roza.
 p. cm. — (Drawing movie monsters step-by-step)
 Includes index.
 !SBN 978-1-61533-015-7 (library binding) — ISBN 978-1-61533-021-8 (pbk.) — ISBN 978-1-61533-022-5 (6-pack)
 1. Monsters in art. 2. Dracula, Count (Fictitious character) in art. 3. Drawing— Technique. I. Title.
 NC825.M6R68 2011
 743'.87—dc22
 2010004901

Manufactured in the United States of America

For more great fiction and nonfiction, go to www.windmillbooks.com.

CPSIA Compliance Information: Batch #S10W: For further information contact Windmill Books, New York, New York at 1-866-478-0556.

Contents

In Search of Blood!

Vampires are **legends**. These stories say that vampires sleep in **coffins** by day. They are said to turn into bats and fly out into the night. In vampire legends, these monsters use their **fangs** to bite their victims and then suck their blood! Vampires are said to be able to control the people they bite.

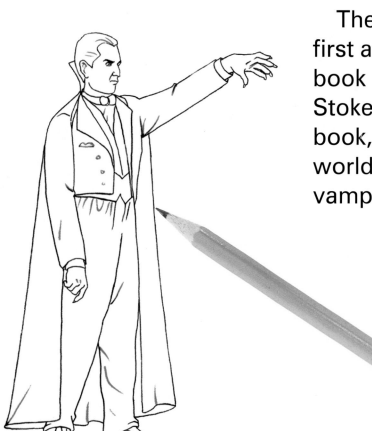

The character Dracula first appeared in an 1897 book by Irish author Bram Stoker. Thanks to Stoker's book, people all over the world became interested in vampires stories.

PENCIL

YOU WILL NEED THE FOLLOWING SUPPLIES:

ERASER

PAPER

RULER

COLORED PENCILS

MARKER

From Stage to Screen

Bram Stoker's novel **inspired** many vampire movies. This includes one of the first horror movies ever made, *Nosferatu* (noss-fuh-RAH-too). In 1922, people thought this German film was very scary!

There were even two plays based on Stoker's novel. This drew the interest of American filmmakers who wanted to make a new vampire movie about Dracula. Actor Bela Lugosi did such a good job playing Dracula onstage that he was asked to star in the 1931 movie!

Actor Bela Lugosi played Count Dracula in the 1931 movie, *Dracula*. Here, Lugosi strikes a classic Dracula pose. Let's draw him.

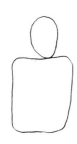

STEP 1

Draw the outline of the head. Add a rounded shape for the body.

STEP 4

Draw the hairline, the collar of the cape, and the vest. Add details to the coat and the cape.

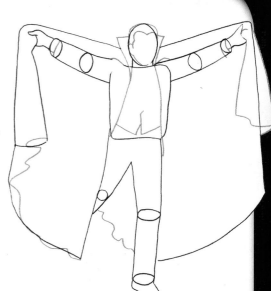

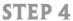

STEP 2

Add small circles and ovals around the body.

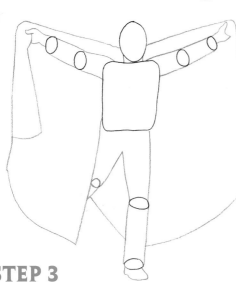

STEP 5

Draw the eyes, nose, and mouth. Add details to the clothes. Erase the guides.

STEP 3

Join the circles to form the arms and legs. Add the outlines of the hands and shoes. Draw the outline of the cape.

STEP 6

Add details to the facial features. Draw the folds in the clothing.

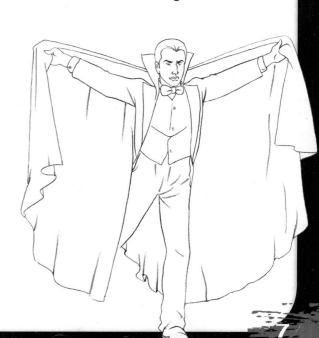

In the 1931 movie *Dracula*, a man named Renfield stays at Castle Dracula in Eastern Europe. Dracula puts him under a spell. Dracula and Renfield then travel by ship to England. Dracula hides in a coffin and feeds on sailors' blood at night.

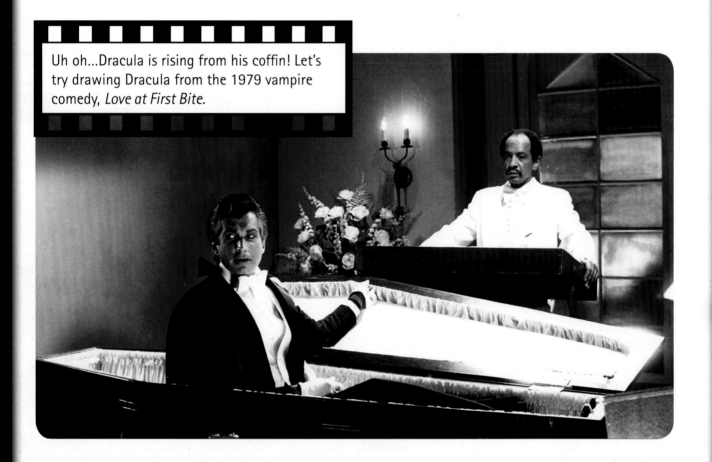

Uh oh...Dracula is rising from his coffin! Let's try drawing Dracula from the 1979 vampire comedy, *Love at First Bite*.

In England, Dracula turns a young woman into a vampire. A man named Van Helsing knows about vampires. It is up to him to stop Dracula!

STEP 1

Draw shapes as
shown to begin the
head and body.

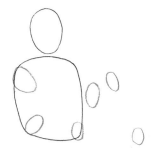

STEP 2

Draw small ovals around
the body to act as guides.

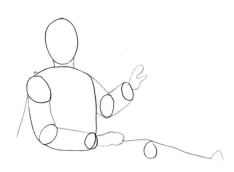

STEP 3

Join the ovals to form arms
and part of Dracula's leg.
Draw hands. Draw two lines
for the neck.

STEP 4

Draw the coffin.
Add the hairline
and jacket.

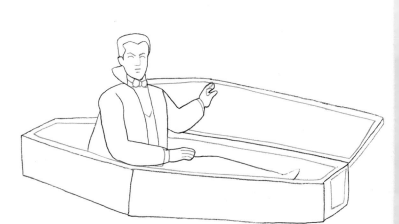

STEP 5

Draw the facial features. Add
details to the hands, clothes,
and coffin. Erase guide ovals.

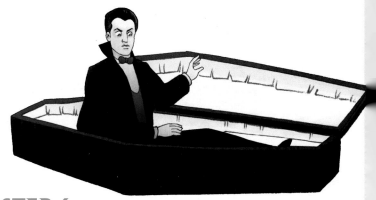

STEP 6

Add details to Dracula's face
and the coffin. Add color.

Hungry...for Blood!

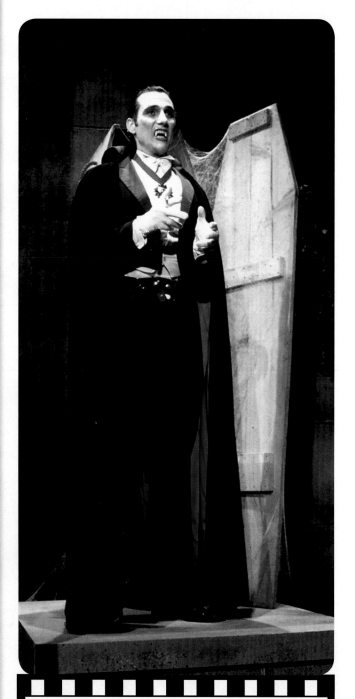

Where does Dracula sleep? In a coffin, of course! Let's learn how to draw the vampire just after he wakes up.

People who saw *Dracula* thought Bela Lugosi played a very scary vampire. Lugosi was from the Eastern European country Hungary. Hungary is near where Dracula was from in the story. In the movie, Lugosi spoke slowly and with his own Hungarian **accent**. This helped make his performance more believable to the audience.

When many people think about vampires, they often picture the type of vampire that Lugosi created for his role in *Dracula*.

STEP 1

Draw a round shape for the head and a boxy shape for the body.

STEP 2

Draw small circles and ovals around the body.

STEP 3

Use the circles and ovals to guide you in drawing the arms, legs, hands, and feet. Add the neck and cape.

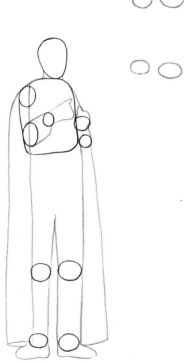

STEP 4

Draw the hair. Add fingers to the hands. Add the cape's collar and the outline of the vest. Draw the outline of the coffin.

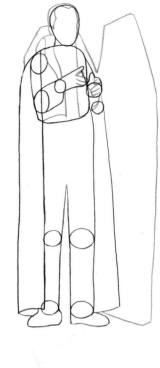

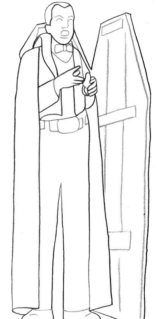

STEP 5

Draw eyes, eyebrows, the nose, and the mouth. Add details to the clothes and the coffin. Erase the guide shapes.

STEP 6

Add the fangs and other facial features. Add more details to the clothing and coffin.

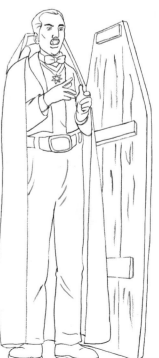

Rise of the Monsters

Dracula was a great success. It helped other movie monsters become popular, too. These include the Mummy and the Wolf Man. Their fans loved to be scared!

Dracula helped make Bela Lugosi a huge **horror** movie star. He played many other scary movie characters, including Frankenstein. In 1944, Lugosi played another vampire in the movie *The Return of the Vampire*. In 1948, Lugosi played Dracula again in a comedy called *Abbott and Costello Meet Frankenstein*.

Here he is—Bela Lugosi as Dracula! Time to draw Dracula before he sees us.

STEP 1

Draw the head, and begin to draw the body.

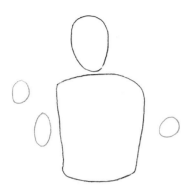

STEP 2

Draw round shapes as shown. These will help you draw the arms and legs.

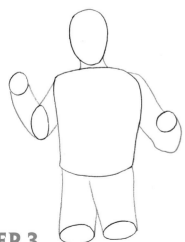

STEP 3

Join the round shapes to form arms and legs. Add lines for the neck.

STEP 4

Draw the hairline and the outline of the face. Add hands. Draw the outlines of the bowtie, jacket, and cape.

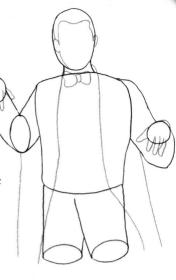

STEP 5

Add the eyes, eyebrows, nose, and mouth. Give Dracula long fingernails. Draw the vest. Add the collar and other details to the coat. Erase the guides.

STEP 6

Add the final details to the face and the clothes. Color your drawing.

Welcome Back, Dracula

After a while, the interest in Dracula and other American movie monsters died down. In the 1950s, British filmmakers began making new **versions** of the classic movie monsters.

In 1958, British actor Christopher Lee starred as the famous vampire in the movie *Dracula*. It was called *The Horror of Dracula* in the United States so that it wouldn't be confused with the 1931 *Dracula*. This British Dracula movie was an instant hit all over the world!

Dracula didn't always have to bite people. Sometimes he put spells on people so that he could control them.

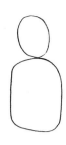

STEP 1
Draw an oval for the head. Add a shape for the outline of the body.

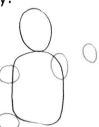

STEP 2
Draw circles and ovals around the body.

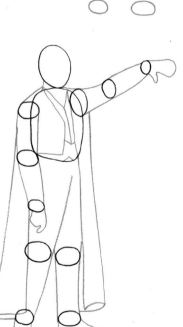

STEP 3
Join the circles and ovals to form the arms, legs, hands, and feet. Draw the outline of the cape and the vest.

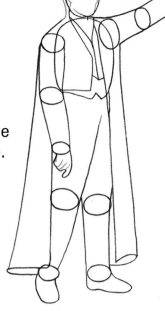

STEP 4
Add the fingers. Draw the outline of Dracula's face and hair. Draw the collar of the cape.

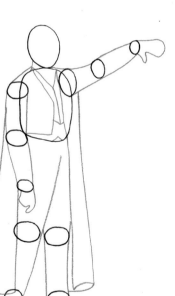

STEP 5
Draw the eyes, nose, and mouth. Add detail to the clothing. Erase extra lines.

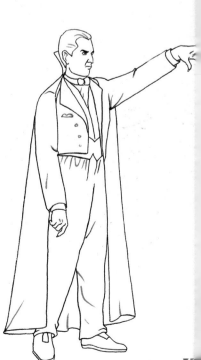

STEP 6
Add more details to Dracula's face and clothes.

Thanks to the success of *Dracula*, Christopher Lee and his costar Peter Cushing became huge horror movie stars. Both appeared in several more Dracula movies. Lee also played Frankenstein and the Mummy.

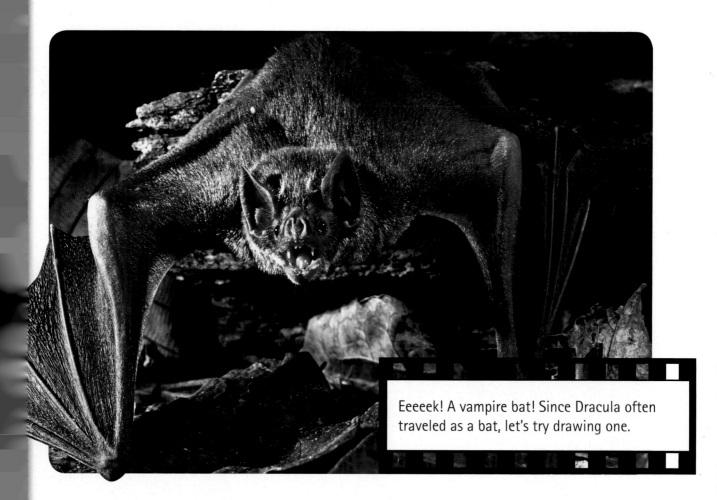

Eeeeek! A vampire bat! Since Dracula often traveled as a bat, let's try drawing one.

American movie fans might also recognize Christopher Lee as Count Dooku from the Star Wars movies and as Saruman from the Lord of the Rings movies. Peter Cushing played Grand Moff Tarkin in *Star Wars Episode IV: A New Hope*.

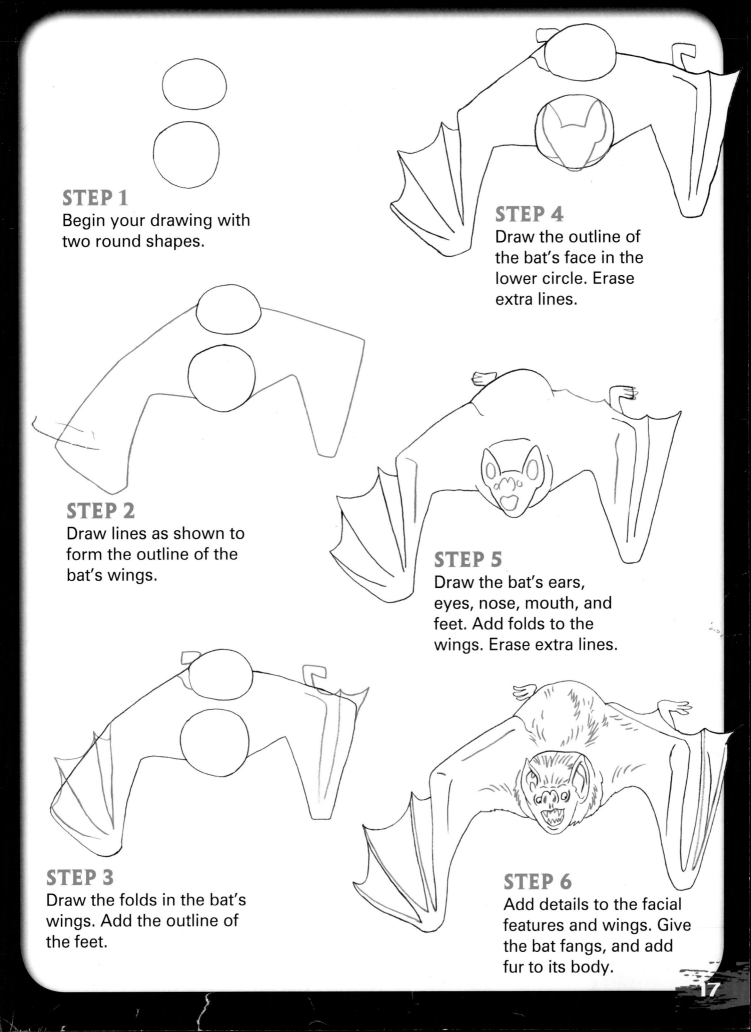

STEP 1
Begin your drawing with two round shapes.

STEP 2
Draw lines as shown to form the outline of the bat's wings.

STEP 3
Draw the folds in the bat's wings. Add the outline of the feet.

STEP 4
Draw the outline of the bat's face in the lower circle. Erase extra lines.

STEP 5
Draw the bat's ears, eyes, nose, mouth, and feet. Add folds to the wings. Erase extra lines.

STEP 6
Add details to the facial features and wings. Give the bat fangs, and add fur to its body.

The New American Dracula

In 1992, American filmmaker Francis Ford Coppola made *Bram Stoker's Dracula*. British actor Gary Oldman brought a new look to the part. His Dracula looked scarier than ever before! Some fans think it is the best vampire movie ever made.

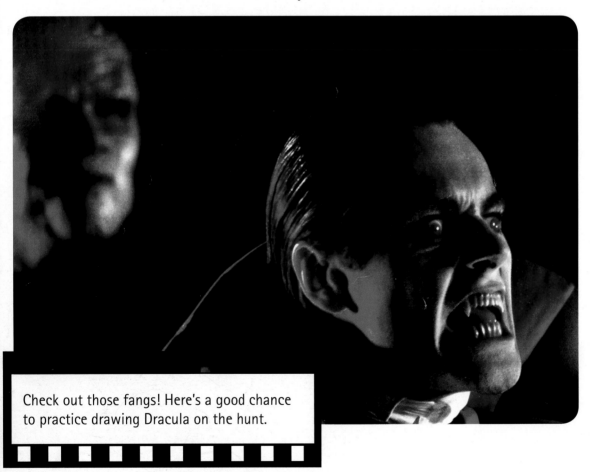

Check out those fangs! Here's a good chance to practice drawing Dracula on the hunt.

The 1992 movie is a lot like Bram Stoker's original book in many ways. For example, Dracula grows younger during the course of the movie, just as he does in Stoker's book.

STEP 1

Draw an egg shape for the head.

STEP 4

Draw Dracula's bowtie. Add lines to his ears and around his mouth.

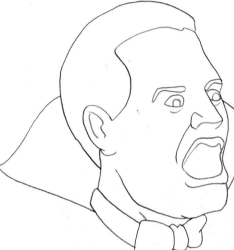

STEP 2

Add shapes to begin the ear, eyes, and mouth.

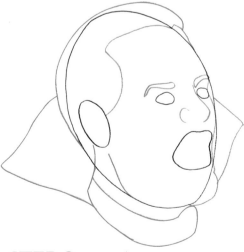

STEP 5

Add to the eyes, nose, mouth, ears, and neck as shown. Erase extra lines.

STEP 3

Add the hair, eyebrows, nose, and neck. Draw the outline of the cape's collar.

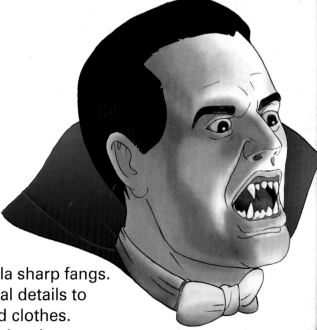

STEP 6

Give Dracula sharp fangs. Add the final details to his face and clothes. Color your drawing.

King of the Vampires

The first vampire movie was made in 1909. Since then, hundreds of movies have featured vampires. Dracula has appeared in more than 150 movies. That's more than any other movie monster.

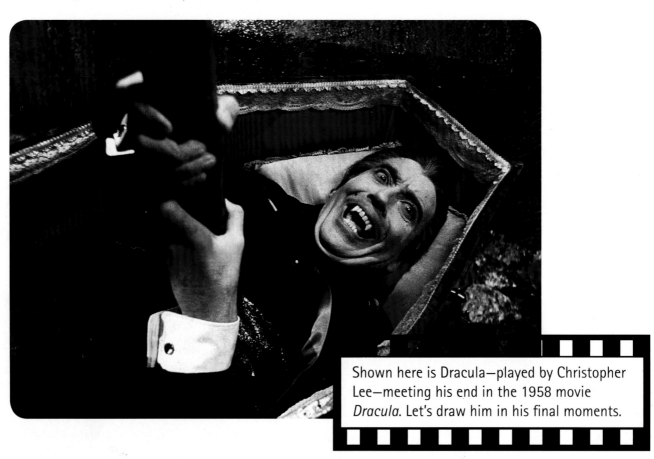

Shown here is Dracula—played by Christopher Lee—meeting his end in the 1958 movie *Dracula*. Let's draw him in his final moments.

But Dracula isn't just a famous movie star. His likeness can be found on TV, in cartoons and comics, and in video games. Dracula has even inspired a breakfast cereal called Count Chocula. The "undead" vampire's popularity continues to live on!

STEP 1

Draw the outline of the head and body.

STEP 4

Add the hair and ears. Draw fingers. Draw the clothes.

STEP 2

Connect the head to the body with two lines. Add guide shapes as shown.

STEP 5

Draw the stake in Dracula's hands. Draw the face, and give Dracula fangs. Add lines to the clothes and coffin. Erase the guides and any other extra lines.

STEP 3

Using the guide shapes, draw Dracula's arms and hands. Draw the coffin.

STEP 6

Add finishing details to the face, hands, clothes, and coffin.

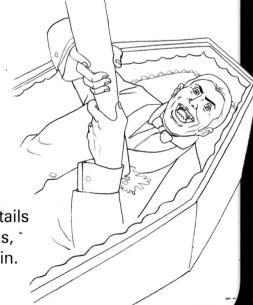

Monster Fun Facts

- The name of Count Dracula was inspired by a real person. Vlad III Dracula was a prince in Eastern Europe during the mid-1400s who was know as "Vlad the **Impaler**."

- When the 1931 *Dracula* was being filmed, a Spanish-language version of the movie was also being filmed at the same time on the same set, but with Spanish-speaking actors.

- Bela Lugosi never blinks during his performance in the 1931 movie *Dracula*. He did this to appear scarier.

- Depending on the legend and the movies, Dracula has many different traits. They often include: fangs, claws, super strength, having no reflection in mirrors, casting no shadow, and the ability to turn into a bat or wolf. Things that can hurt or kill Dracula often include garlic, crosses, fire, sunlight, and putting a wooden stake through his heart.

Glossary

ACCENT (AK-sent) A way of speaking that reflects where a person is from.

COFFIN (KAH-fun) A box that holds a dead body.

FANGS (FANGZ) Sharp, hollow, or grooved teeth that inject venom.

HORROR (HOHR-ur) A strong feeling of shock or fear.

IMPALER (im-PAY-lur) One who has impaled another person. To impale means to drive a sharp object through something.

INSPIRED (in-SPY-erd) To have moved someone to do something.

LEGEND (LEH-jend) A story, passed down through the years, that cannot be proved.

VERSION (VER-zhun) A thing that is different from something else, or has different forms.

Emberley, Ed. *Ed Emberley's Drawing Book of Halloween*. New York: Little, Brown, 2006.

Jungman, Ann. *Vlad the Drac*. London: Barn Owl Books, 2008.

Tallerico, Tony. *Monsters: A Step-by-Step Guide for the Aspiring Monster-Maker*. Mineola, NY: Dover Publications, 2010.

Index

Web Sites

For Web resources related to the subject of this book, go to:
www.windmillbooks.com/weblinks and select this book's title.